ELY
HISTORY TOUR

First published 2016

Amberley Publishing
The Hill, Stroud,
Gloucestershire, GL5 4EP
www.amberley-books.com

Copyright © Pamela Blakeman, 2016
Map contains Ordnance Survey data
© Crown copyright and database right
[2016]

The right of Pamela Blakeman to be
identified as the Author of this work
has been asserted in accordance with
the Copyrights, Designs and Patents
Act 1988.

British Library Cataloguing in
Publication Data.
A catalogue record for this book is
available from the British Library.

ISBN 978 1 4456 5689 2 (print)
ISBN 978 1 4456 5690 8 (ebook)

Typesetting by Amberley Publishing.
Printed in Great Britain.

ACKNOWLEDGEMENTS

Grateful thanks to Donald Monk for providing the photographs on pages 11 and 39. Thanks too for helpful advice from Marianne Edson, Beth Lane and particularly from Michael Rouse, plus computer assistance from Chris Holley.

INTRODUCTION

The Cathedral City of Ely on the River Great Ouse is a rapidly expanding market town with a population approaching 20,000. Situated on a low hill, the cathedral is visible for miles across the surrounding flat fen countryside, as it has been for over 900 years. It also provides a splendid backdrop to views of the city and can be seen from every part of this tour. The medieval precincts of the former monastery, with the streets and buildings, provide continuity and stability in the heart of the city.

The Market Place has, in some areas, changed drastically, as you will soon realise. Buildings on the Market Place were replaced with what is generally agreed to be a banal, undistinguished block of shops. Later, part of the north side was demolished to make way for the entrance to The Cloisters – a new shopping area. From medieval times up until 1992, fairs were held on the Market Place. To begin with they were associated with St Etheldreda, foundress of the monastery in Ely, from which the cathedral developed.

Since the middle of the nineteenth century most of the premises in the city centre occupied by shops have remained the same, though retailers have changed – in some cases several times. In the city centre changes to existing buildings, except on the Market Place, have been relatively small. The largest new residential developments, which this tour does not include, are around the

outskirts to the west and north where further development is expected.

Today, with no brewery, no leather factory, no beet sugar factory (nearby at Queen Adelaide), no 'jam' factory, the remainder of Ely's profitable industries are 'high tech', with one such industry located in the Cambridgeshire Business Park, situated towards the bypass. Ely's biggest employer is King's Ely (previously King's School), a school that caters for all ages and abilities.

In spite of the increase in population and the resulting increase in traffic, Ely remains a comparatively peaceful city for most of the week. On market days (Thursdays, Saturdays and recently some Sundays) and at weekends, Ely is bustling with shoppers, visitors and tourists.

Whatever the changes happen to be, the essential heart of the medieval city remains today, represented by the cathedral and its unique central octagon tower, visible not only around the city but also for miles around.

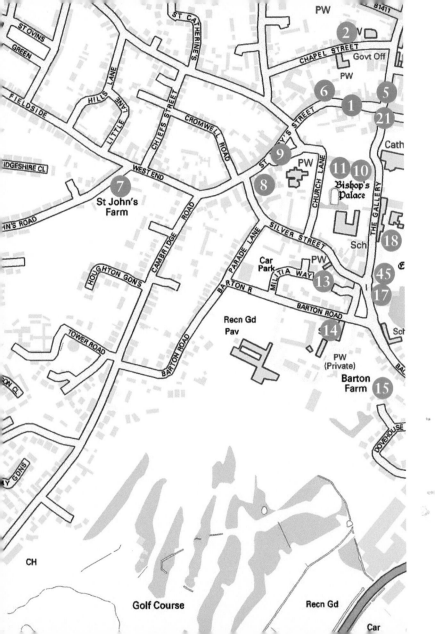

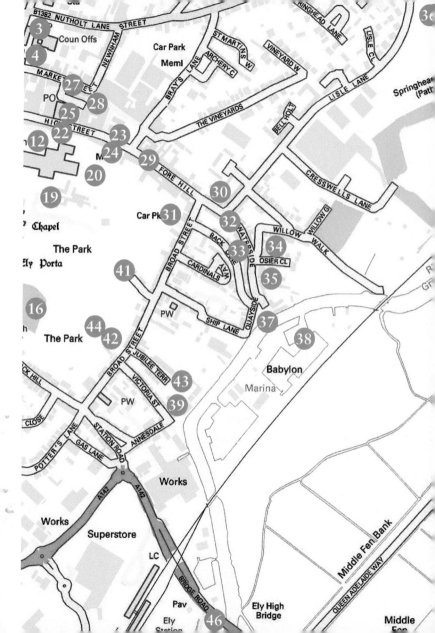

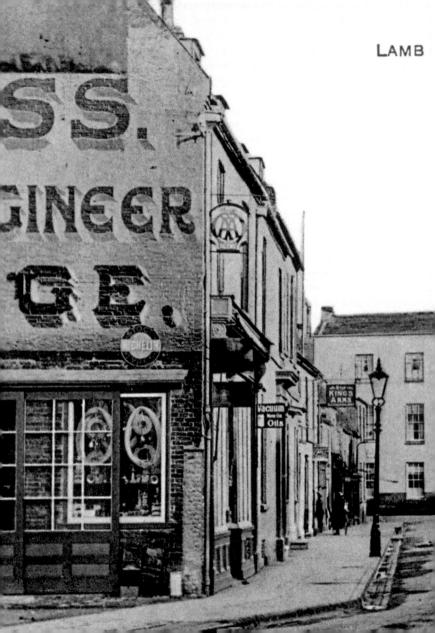

LAMB

1. TOWARDS THE LAMB HOTEL

Straight ahead, on a site where a hostelry has been since at least the fourteenth century, is The Lamb Hotel. Now an Old English Inn, this is still Ely's main hotel. On the left is A. Cass, Motor Engineer Garage. Alexander Cass began his business nearby but moved to these larger premises during the First World War. Opposite, outside a blacksmith's, a carriage waits for the return of a horse.

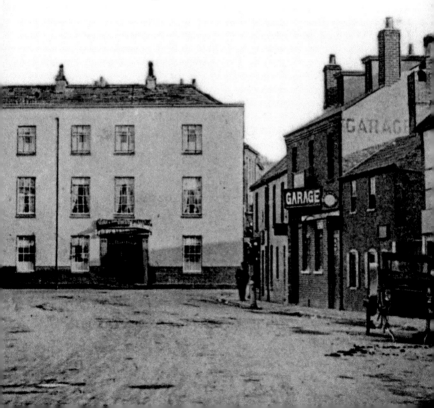

2. COUNTESS OF HUNTINGDON CHAPEL

In Chapel Street, dating from the eighteenth century, is this typical 'meeting house' of its time. Externally it remains almost untouched. In 1985 the interior was altered considerably, though the gallery has been retained. If you continue around 1.5 km along Lynn Road you will come to The Princess of Wales Hospital, now a community hospital and once an important Royal Air Force hospital from 1940 to 1992.

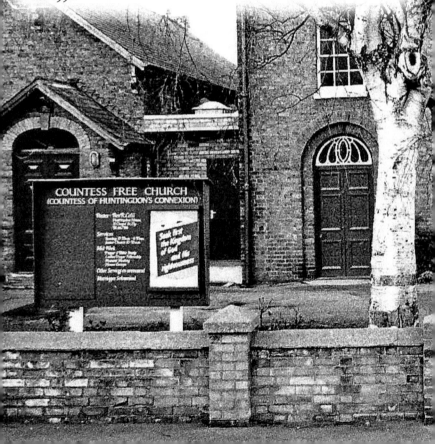

3. THE SESSIONS HOUSE OR SHIRE HALL

Before you return to the area traditionally known as the Lamb Corner, look at the imposing building in front. It was built in 1821 and was designed by architect Charles Humphrey. It is now fully restored and the exterior remains intact, as does much of the inside including a nineteenth-century courtroom. Part of the building was once used by the Cambridgeshire Rifles and part as a police station. Since 2013 it has been owned by the City of Ely Council.

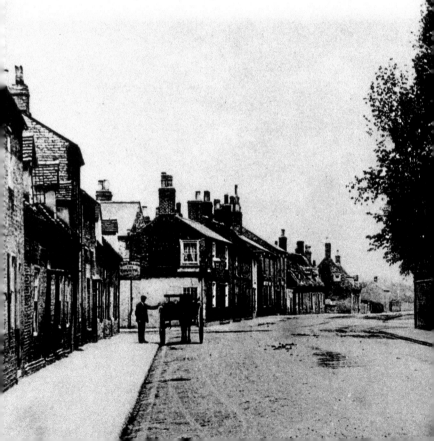

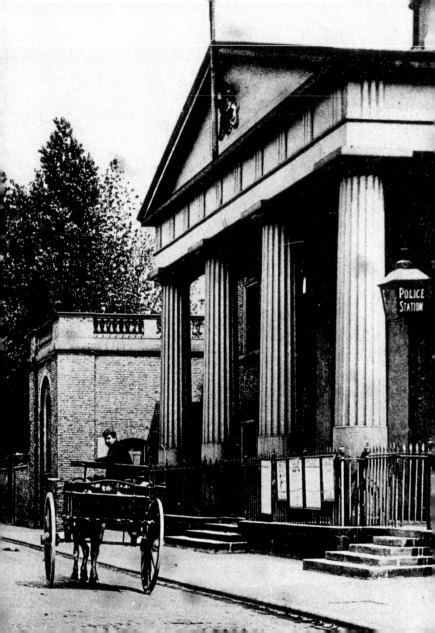

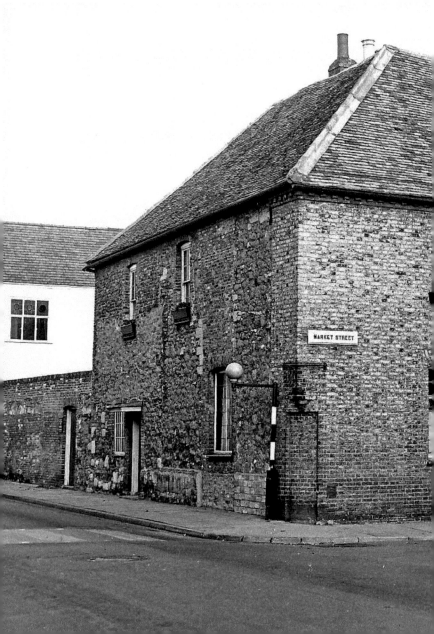

4. ELY MUSEUM, THE OLD GAOL

Part of the building dates back to before the fourteenth century. It became the Bishop's gaol in 1667 and remained so until 1836 when the Liberty of Ely and the Bishops' jurisdiction over the Isle of Ely ended. After various uses, this old gaol has housed Ely Museum since 1996. First opened in High Street in 1972, it was officially reopened here in 1997 by noted local historian Michael Petty, MBE, MA, ALA.

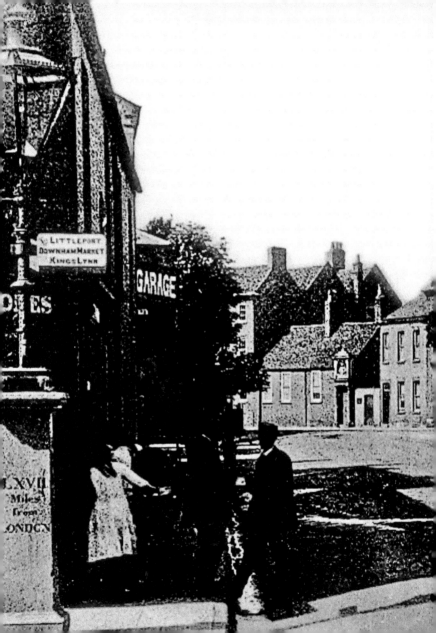

5. FROM THE LAMB HOTEL LOOKING WEST

The tall milepost on the left was knocked down in around 1930. On the right is a building that was once a farmhouse, next to the King's Arms, and beyond it a smaller shop. The latter was converted in 1991 back to residential use after many years as a garage showroom. Seen in the distance is Bedford House. Also on the left, not seen in this photo, is the old Dispensary, opened in 1865.

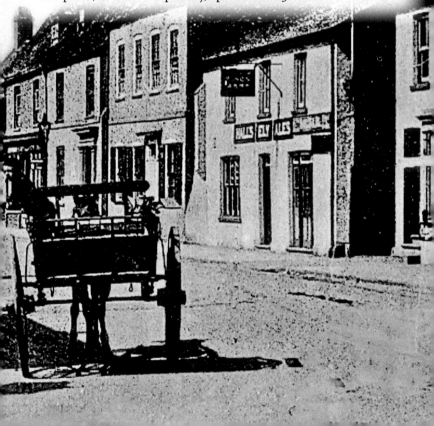

6. BEDFORD HOUSE

Bedford House, built as a private house in the early years of the nineteenth century, was, from 1844 to 1864, headquarters for the Bedford Level Corporation, the body responsible for the main drainage of the Fens during the seventeenth century. (Note the coat of arms over the doorway, also found inside as stained glass.) From 1905–53 it housed Ely High School for Girls, but the single-storey section remained as offices of the corporation until 1967. After various educational uses the building was given over to become flats and a day centre.

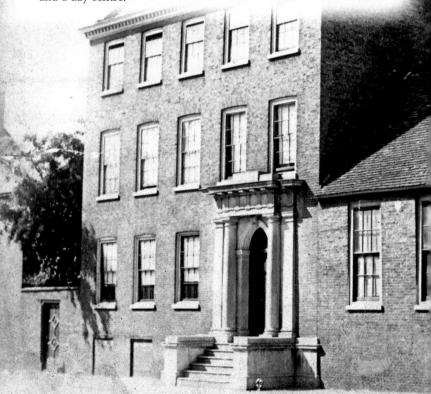

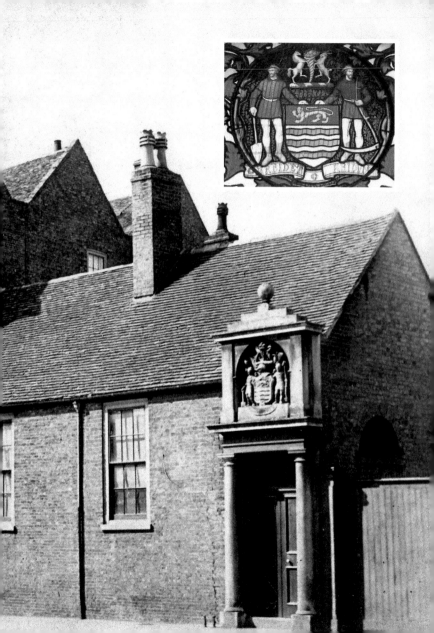

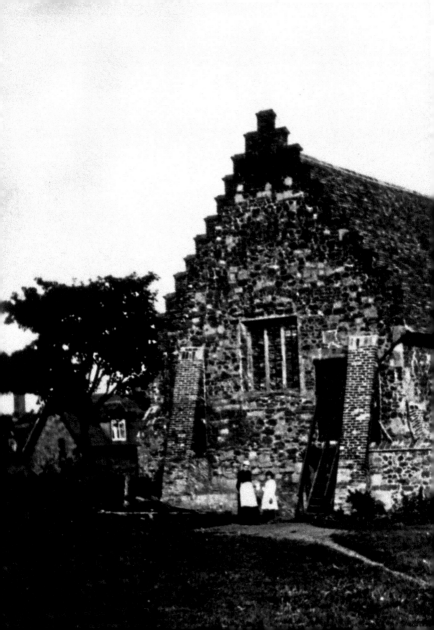

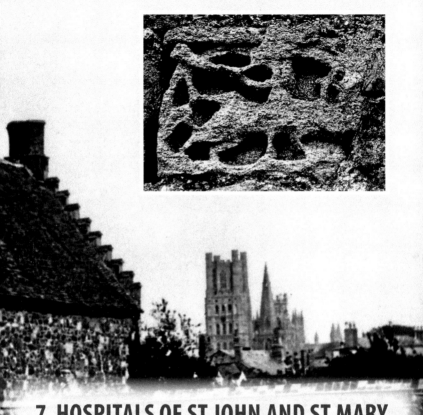

7. HOSPITALS OF ST JOHN AND ST MARY

Around 500 metres further on, two remaining buildings are thought to have been chapels of two hospitals that were united in 1240. Clare College, Cambridge, owned the site when it was larger and extended towards Cambridge Road. It is now privately owned. On the barn around the corner is an ancient carving of an animal with a seated man on its back; he is blowing a trumpet in the direction of the cathedral.

8. OLIVER CROMWELL HOUSE, ST MARY'S CHURCH AND THOMAS PARSONS' ALMSHOUSES

For a short time in the seventeenth century this was the home of Oliver Cromwell and his family. After it had ceased to be the Cromwell Arms in 1871, it retained a plastered façade but later was altered to its present timbered appearance. In 1905 it became St Mary's Vicarage, later bought by East Cambs District Council. In 1990 it opened as a tourist information centre. St Mary's Church was begun early in the thirteenth century and was continually developed over the centuries. On the right is Parsons' charity almshouses, built 1844.

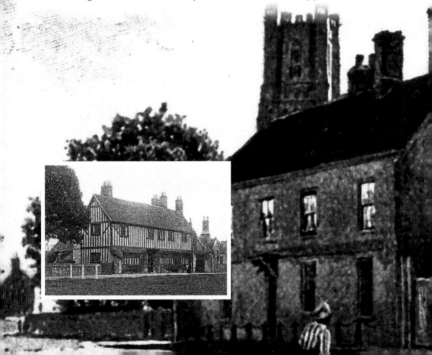

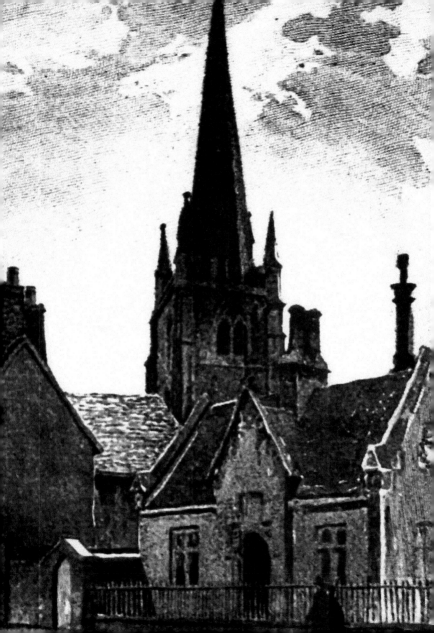

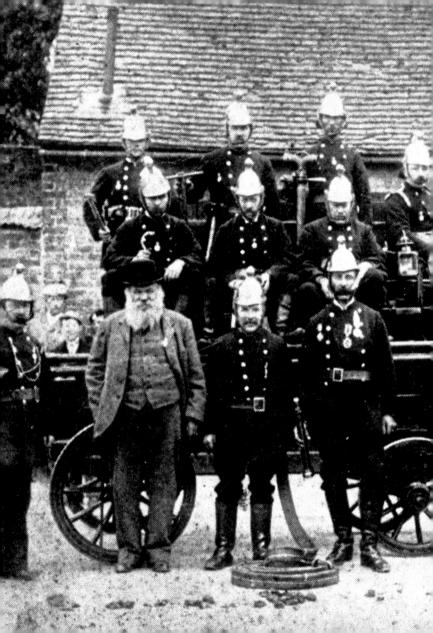

9. OLD FIRE ENGINE HOUSE

Two fire brigade engines were housed here with much of the equipment nearby. An official brigade was formed in 1904, and in 1912 new premises, including a practice tower, were built next to the old gaol on Lynn Road. Since 1943 it has been located in Egremont Street. Old Fire Engine House is now a popular restaurant and art gallery.

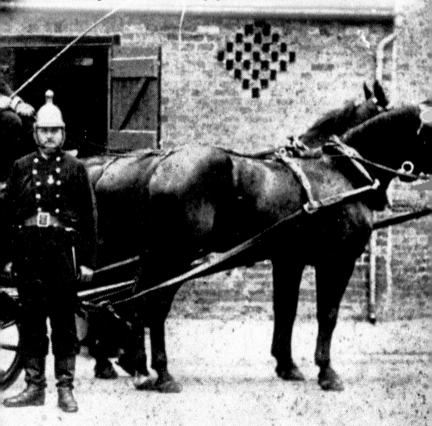

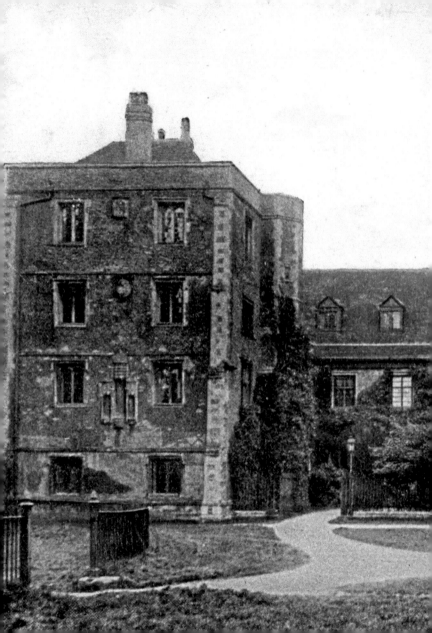

10. THE BISHOP'S PALACE

The east tower dates back to the fifteenth century, the long gallery to the sixteenth, and the central area between the two towers to the seventeenth. In the grounds there is an oriental plane tree said to have been planted by Bishop Gunning in the late seventeenth century and reputed to be the largest in the country. On the Palace Green is a Russian trophy gun given in 1860 by Queen Victoria to mark the formation of the Ely Rifle Volunteers.

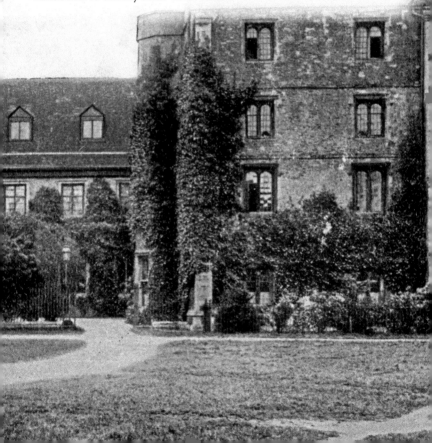

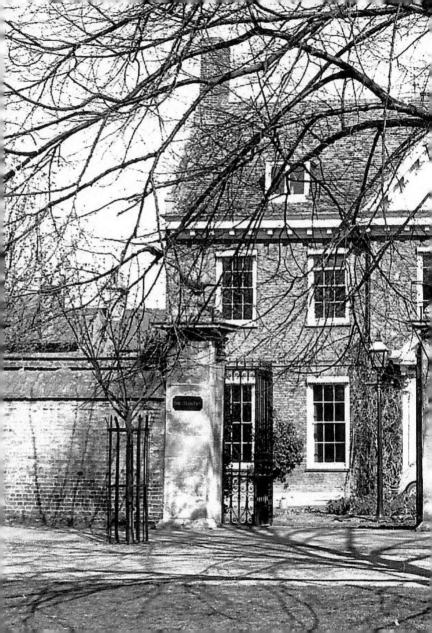

11. THE CHANTRY

The fine seventeenth-century house known as The Chantry is on the site of Bishop Northwold's Chantry founded in 1250. Four priests were appointed to sing mass for his soul and for the souls of King Henry III and Queen Eleanor. Note the fire insurance plates of the Sun Assurance Fire Co. on the façade. Nearby is a second well-proportioned residence, and since 2000 the Cathedral Education & Conference Centre in the former library building.

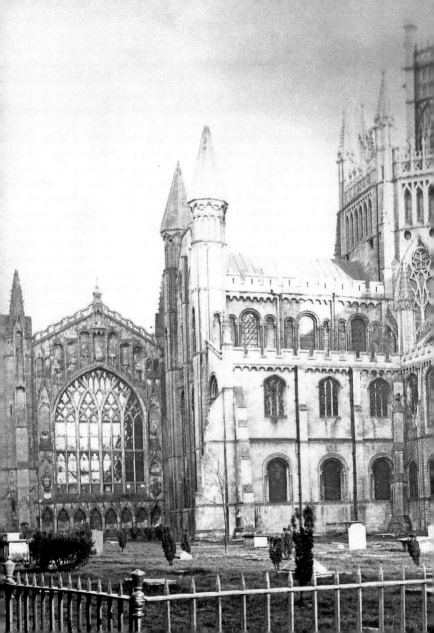

12. CROSS GREEN GRAVEYARD

Ely's second parish, Holy Cross, was moved into the Lady Chapel in 1566 and renamed Holy Trinity. In 1938 this parish was united with St Mary's to form the Parish of Ely. Many of the victims of the 1832 cholera outbreak were interred in this graveyard which by 1855 was full. Most of the old remaining memorial stones were cleared in the 1960s. Now a variety of events take place here & many tourists enjoy relaxing in this open space.

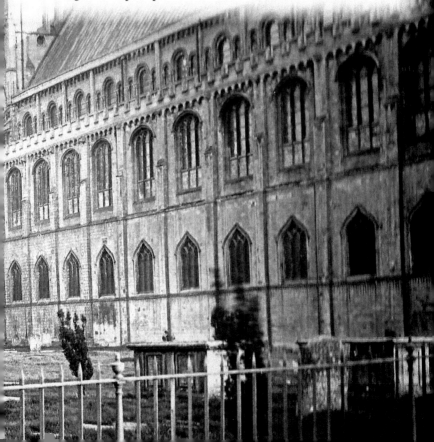

13. SILVER STREET COTTAGES

Three timbered cottages, Nos 7, 9 and 11, may go back to around 1400, when they formed a single wealden-type house. Inside the first two are interesting medieval mural paintings. In No. 9 are vine scrolls, while upstairs in No. 7 are fascinating grey, terracotta, and black-and-white murals of, for example, a peacock with the words 'Be not Proud' and a dove, 'Deale justlye'.

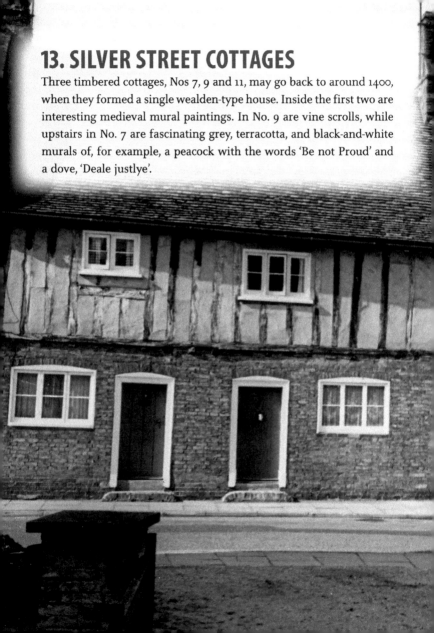

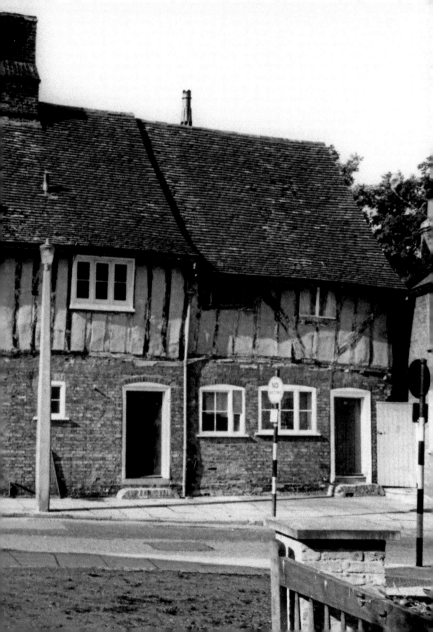

14. THEOLOGICAL COLLEGE

The college was founded by Bishop Woodford in 1876. This building dates from 1881 and was used for its original purpose – to train men for ordination – until the college closed in 1964. It is now used by King's Ely. Next door is Bishop Woodford House, a Diocesan retreat centre opened in 1973.

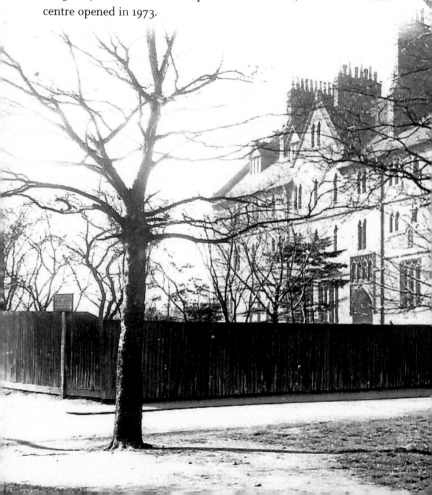

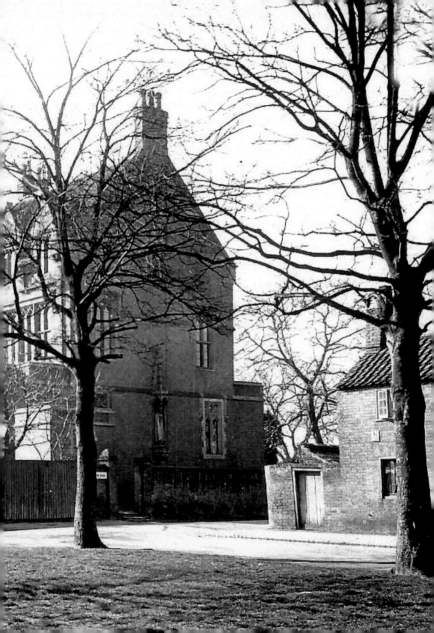

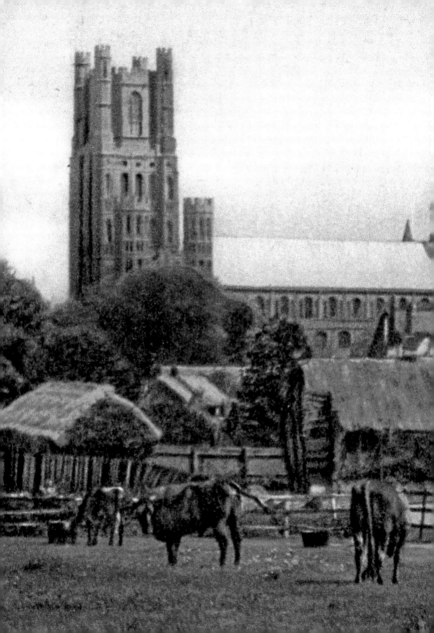

15. BARTON FARM

Around 20 metres along the public footpath you will see the old farmhouse, and a little further into the field you will come across this view of the cathedral and a view across the countryside. Robert Arthur Martin ran the farm with his family and delivered milk to local residents soon after the First World War until 1971. They leased the farmhouse and some of the land from the Church Commissioners. It is now part of the King's Ely complex.

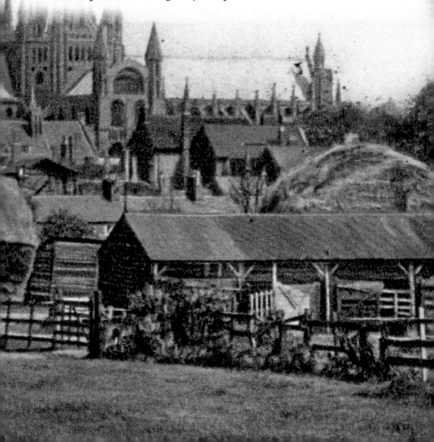

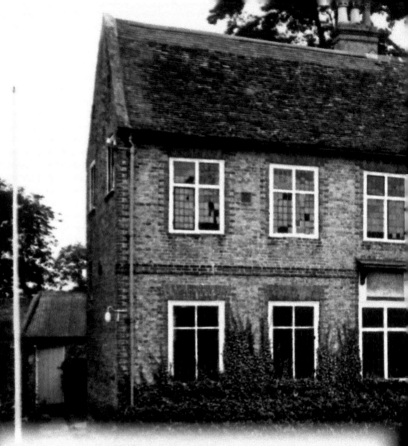

16. NEEDHAM'S SCHOOL

This boys' school on Back Hill was founded following the will of Catherine Needham in 1740. It provided education and clothing for boys whose parents could not afford to pay more than a few pence per week. In 1968 the school moved to new premises. This building is now used by King's Ely. Today Kings, who claim its foundation dates back over 1,000 years, caters for all ages and abilities, in a number of buildings both old and newly built.

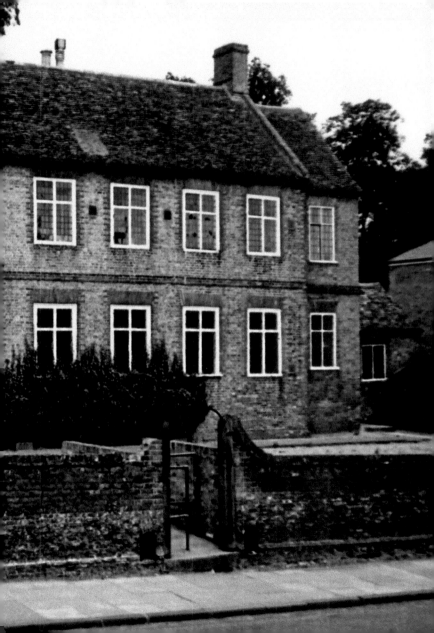

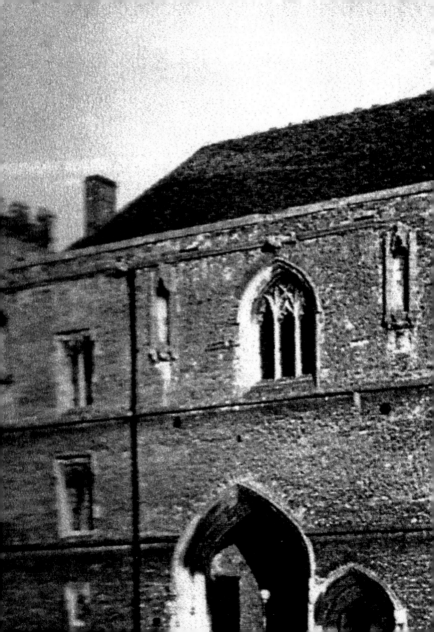

17. THE PORTA

The existing gateway to the cathedral precincts, or The College as the area is known in Ely, was built in the fourteenth century and now houses King's Ely's library. Through the gate on the left is the early fourteenth-century Prior Crauden's Chapel and Priory House, and now on the right the monastic barn, Kings' dining hall. The road alongside the Dean's Meadow leads to the cathedral south door and Firmary Lane.

18. PRIOR CAUDEN'S CHAPEL AND PRIORY

Built by Prior Crauden over an earlier undercroft, the chapel, threatened with demolition, survived the Commonwealth as it was in use as a private house at the time. Today this small chapel, with its tiled floor that includes a unique panel depicting Adam and Eve, delights visitors. The former priory buildings, seen here on the right, date from the mid-twelfth century but were much altered in the fourteenth.

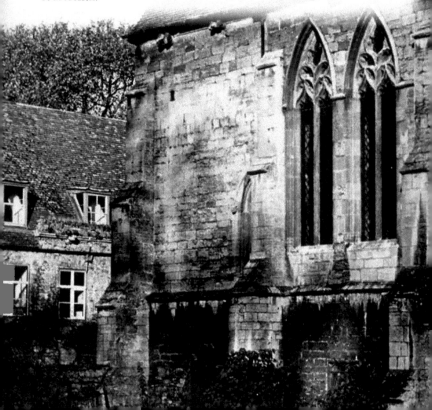

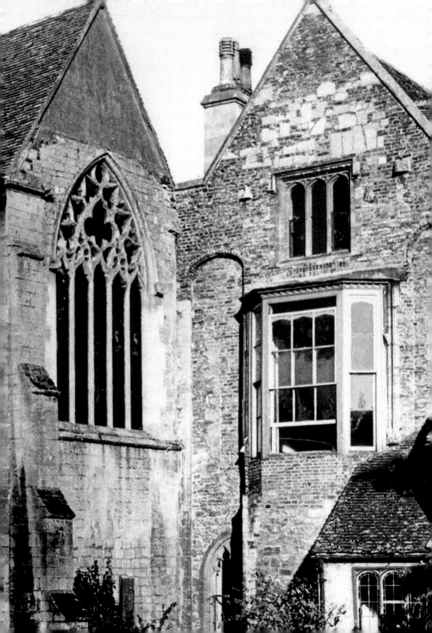

19. FIRMARY LANE

Firmary Lane was once roofed over to form the main hall of the aisled monastic infirmary. Built in 1160 to 1180, it has, on either side, blocked arcades which now form the outer walls of two houses. Both Powcher's Hall on the left and the Black Hostelry on the right have developed over the centuries to become canonry houses. At the far end are the remains of the monastic chapel and the later deanery.

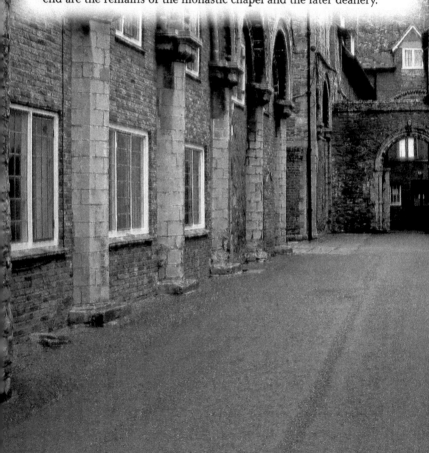

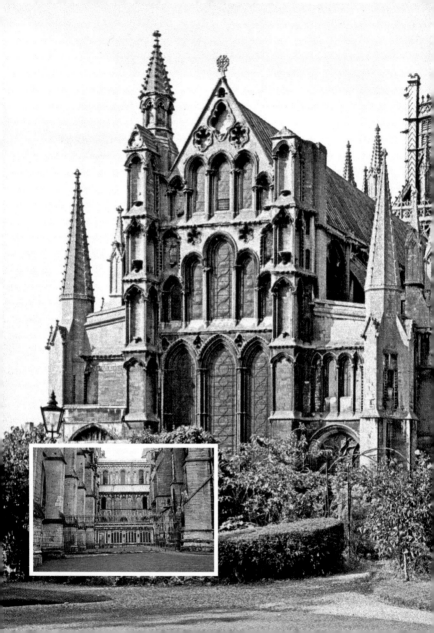

20. EAST END, OCTAGON AND LADY CHAPEL

This view has changed since 2000. A new Processional Way, leading from the choir stalls to the Lady Chapel, designed by the Surveyor to the Fabric, Jane Kennedy, was built on the site of the former medieval passage. Traditional design and materials fit harmoniously with surrounding medieval architecture. A few metres away, in the shadow on this photo, are railings to protect the new windows.

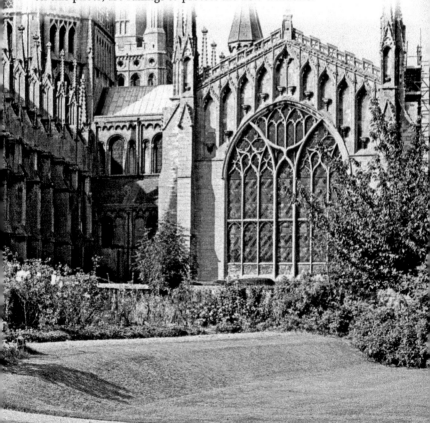

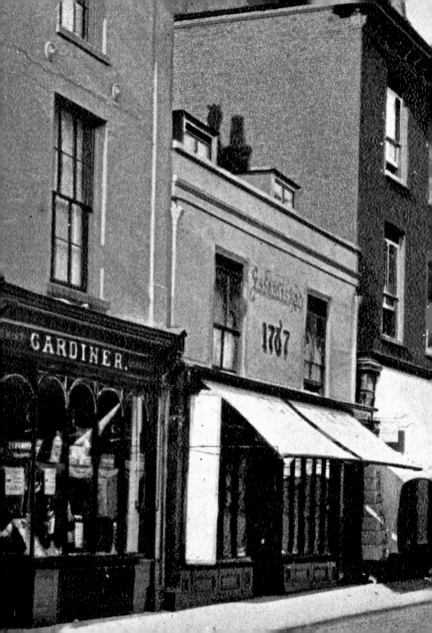

21. HIGH STREET FROM THE LAMB CORNER

Continue alongside Cross Green and turn right to this end of High Street. On the right a tree, once in the yard in front of the doctor's house, is where a range of new shops were built in 1936. On the left, a number of shops, including Legge's 1767 (now Gibbs), remain. The tall red-brick building, then a draper's, was built using traditional yellow bricks. Further along the light-coloured corner block was the County & Country Bank, later a café. On the opposite corner is a small new build.

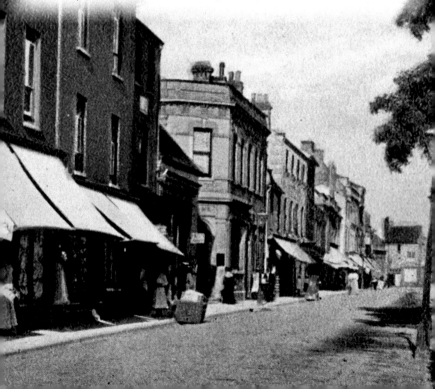

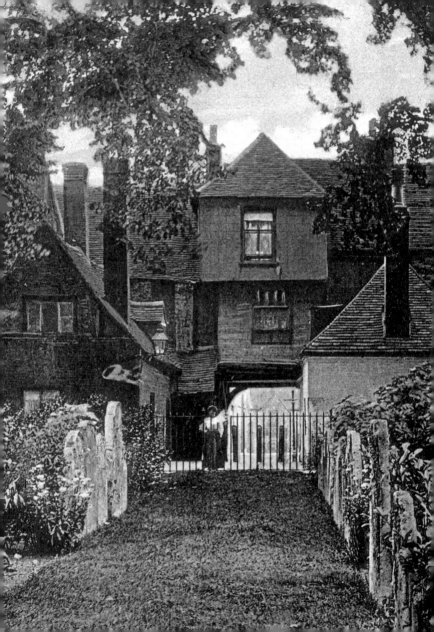

22. STEEPLE GATE AND SACRIST'S GATE

Steeple Gate, an entry to the precincts, dates back to before 1417; previously St Peter's tower was on the site. Today's building is of various dates from the fifteenth century and is over a fourteenth-century undercroft. It was restored in 1978 and opened as tea and craft shop.

Sacrist's Gate, built 1325/26 also leads to the precincts. It was built by Alan of Walsinham, who is also credited with masterminding the building of the cathedral's octagon tower in the fourteenth century.

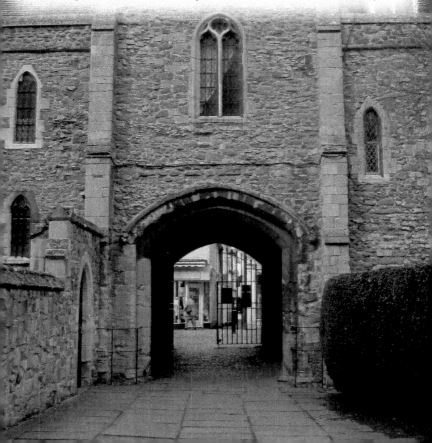

Ely High Street looking

A Happy New Year

23. HIGH STREET TOWARDS LAMB CORNER

On the left is part of the range of buildings that form the northern boundary of the former monastic area, further along is Barclay's Bank. On the right the buildings have changed little apart from the new build, replaced windows on one building and the removal of a unique bay window just to the right of this photo.

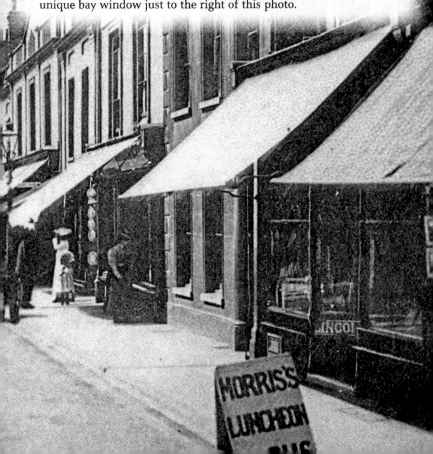

24. ELY WAR MEMORIAL

A temporary wooden memorial was erected in 1917. A permanent memorial, unveiled 30 April 1922, records over 300 names of men killed in both world wars. In 2009 a plaque was added 'In Memory of the Fallen from 1945 to the Present Day'. Recent archaeological work near the almonry confirmed the existence of an earlier entry to the monastic area. On the left is the badge of the diocese – three crowns – and on the right is that of the dean and chapter – three keys.

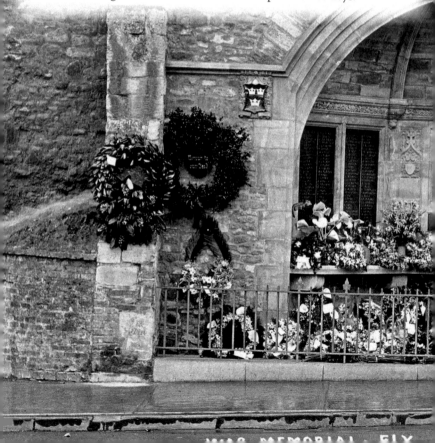

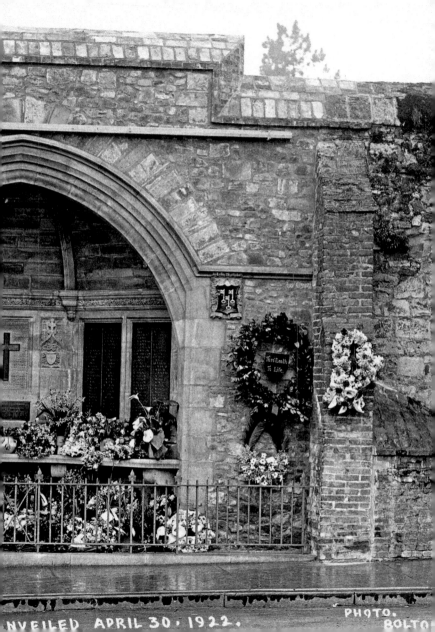

NVEILED APRIL 30 · 1922.

PHOTO.
BOLTO

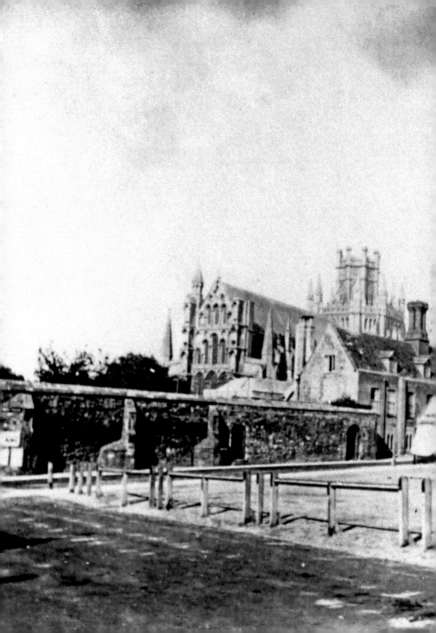

25. MARKET PLACE, SESSIONS HOUSE

Here at Sessions House, to the right of the three-storey building, five Ely and Littleport rioters were condemned in 1816 to be hanged. A girls' school occupied the top floor. The building was demolished and a public room and a corn exchange were built in the first half of the nineteenth century. Before the present flat-roofed shops were erected in the late 1960s, the reading room had many uses and was a cinema until 1963.

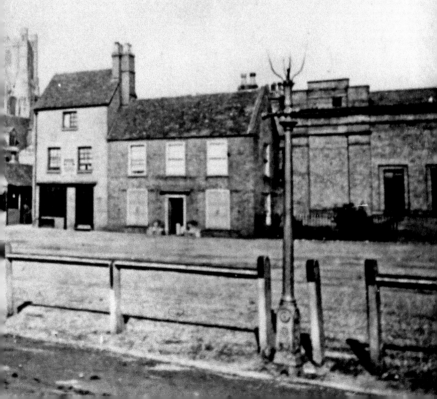

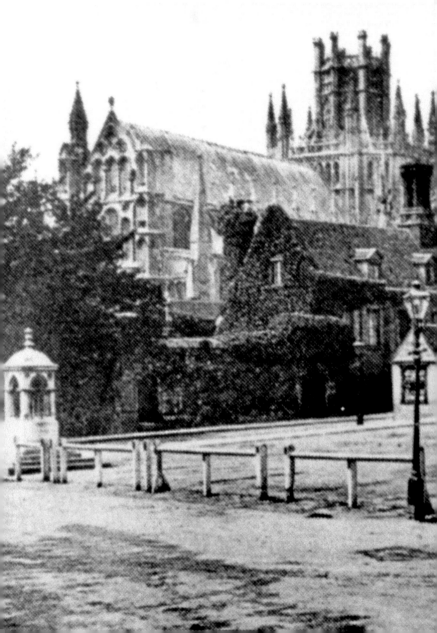

26. MARKET PLACE, PUBLIC ROOM

The three-storey house remains unchanged since the early nineteenth century. The Public Room, later the Exchange (in this photo on the site of the Sessions House) were both demolished in 1964 to be replaced by two-storey flat-roofed shops. On the left is the fountain that marked Queen Victoria's 1897 Jubilee, moved in 1939. Closer to the cathedral, the almonry and, to the extreme right, is the side of the 1847 Corn Exchange.

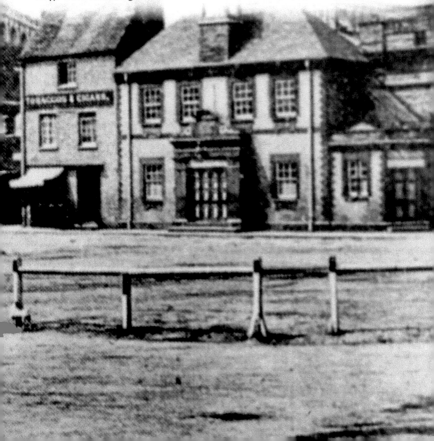

27. KEMPTON'S CORNER

To the right of the Corn Exchange site, look through to Market Street. Kempton's fruit merchants on the corner had been in business since the sixteenth century. The corner was rebuilt 1936. The family traded under this name until the 1970s. On the right is the White Hart Inn (closed 1996). In the distance is the Woolpack Inn (closed 1971) and the art deco façade of the Rex cinema, replaced by a bank and Boots chemists.

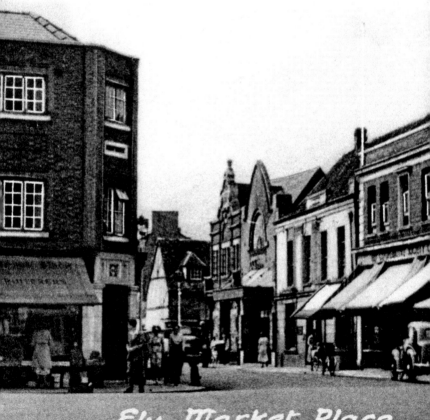

Ely Market Place

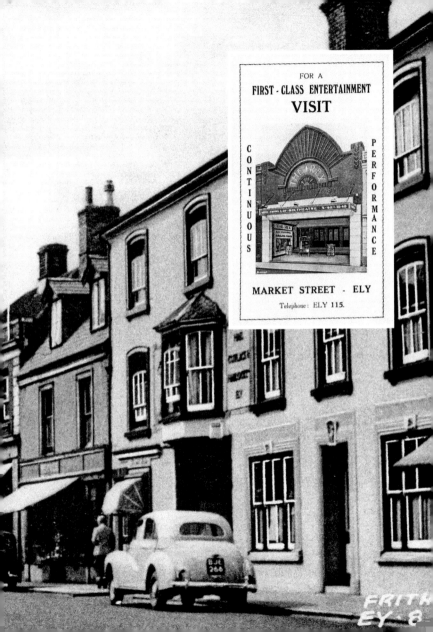

FOR A

FIRST-CLASS ENTERTAINMENT

VISIT

C O N T I N U O U S

P E R F O R M A N C E

MARKET STREET - ELY

Telephone : ELY 115.

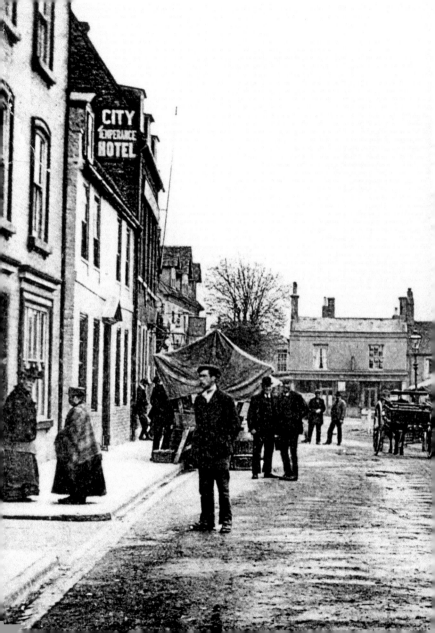

28. MARKET PLACE, CORN EXCHANGE

With the White Hart on the left, the Corn Exchange on the right dominated the view from 1847. The cattle market took place around the front of the Sessions House. This changed in 1846 when a new cattle market opened behind the White Hart. Here was also the City Temperance Hotel, and straight ahead shops remain though the lookout tower has now gone.

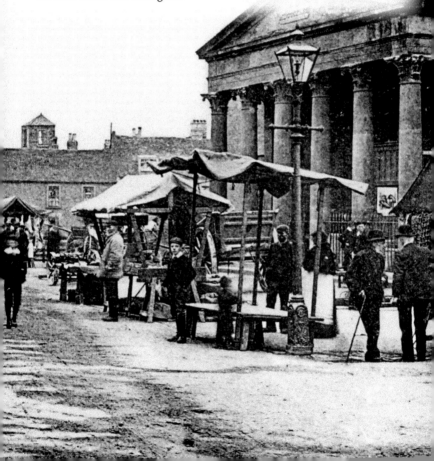

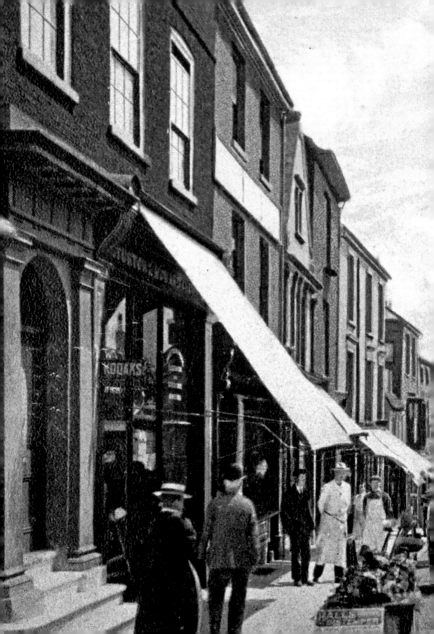

29. LOOKING DOWN FORE HILL

Many of the buildings have changed little during the last 150 years, that is, above the shops; the skyline is still familiar. Of course businesses have changed and the steps on the left, that led to a private house, were demolished sometime after the Second World War. The road leads straight down to Waterside and the River Great Ouse.

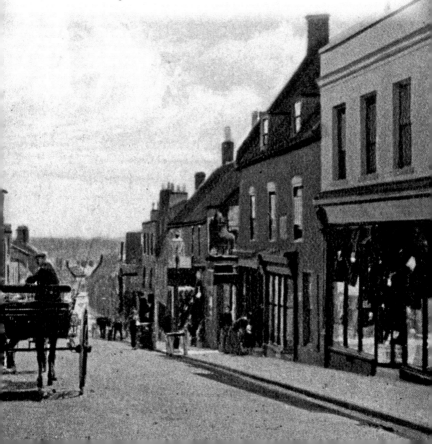

30. THE BREWERY

The imposing entrance faced down Broad Street with a clock over the archway. The brewery was an important workplace in a small town. After several changes of local ownership, the East Anglian Breweries Ltd took over in the 1950 and finally Watney Mann (East Anglia) Ltd. The brewery closed in 1969 and Old Brewery Close was built at the back of the former brewery premises. The gates and posts remain, showing the location of the brewery.

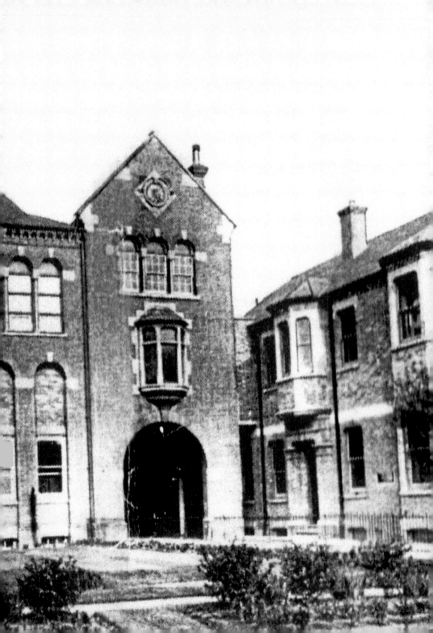

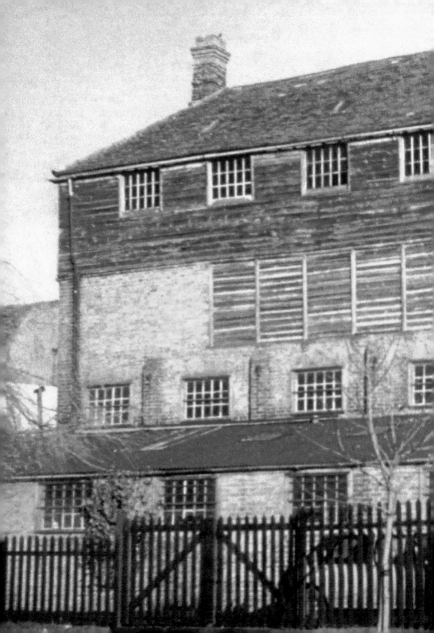

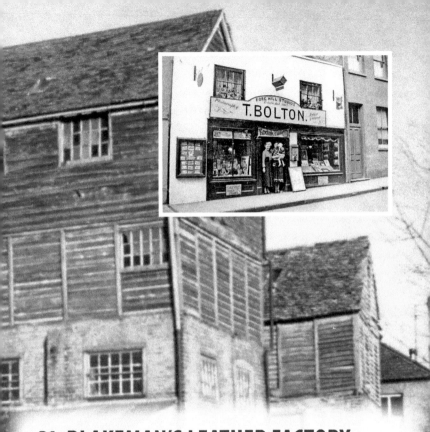

31. BLAKEMAN'S LEATHER FACTORY

The entrance to the factory was on Broad Street, with shop and house on Fore Hill. Blakeman's leather merchants and curriers traded from the early years of the nineteenth century. Business flourished during the First World War but by the time Thomas Blakeman died in 1944 trade had declined. Later this property, along with other buildings, was sold to developers and demolished in 1973. The site of the factory is now the car park for the office block on the corner of Fore Hill and Broad Street.

32. LOOKING UP FORE HILL

The gas lamp clearly needed attention. It is just below the site of the brewery and above the premises of J. H. Clements, printers. On the far left is the former Glaziers Arm and on the corner a grocer's, later a butcher's. Most of the premises on this lower part of Fore Hill have been demolished.

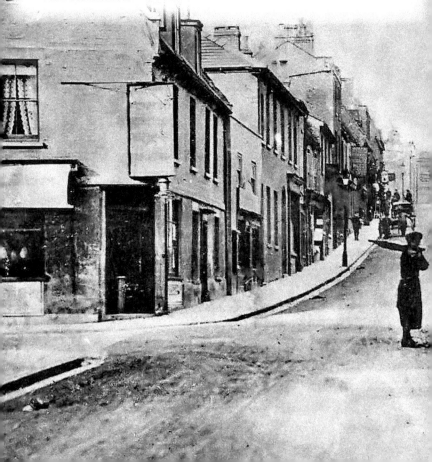

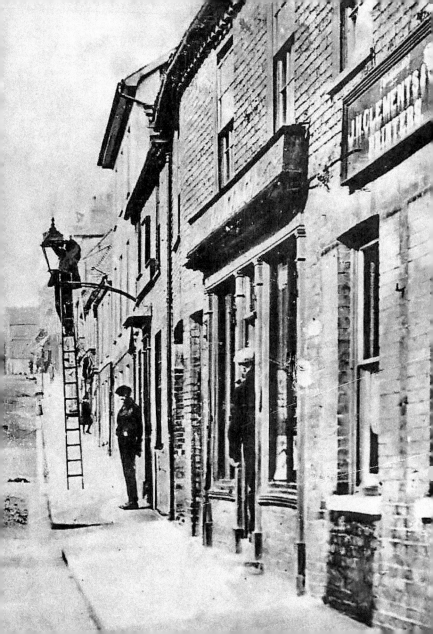

33. TOWARDS THE RIVER

For many hundreds of years Waterside was the most important route to the monastery and centre of Ely for tradesmen, pilgrims and other visitors, many of whom came by water. After a period of neglect this has become a fashionable residential area. Next to the Black Bull was a grocer's shop, now a chandler's. At the beginning of the last century there were around seventy public houses in Ely – a good number in the river area.

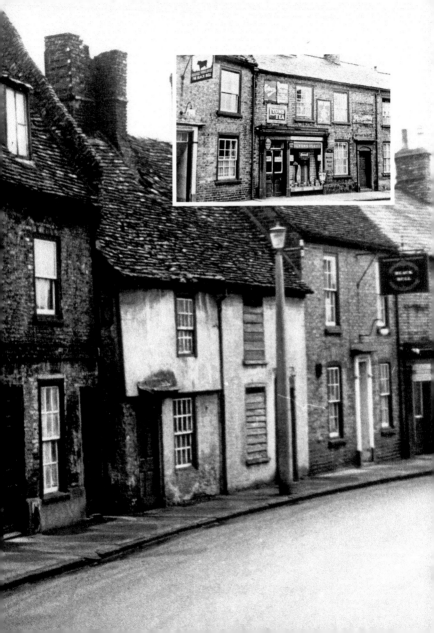

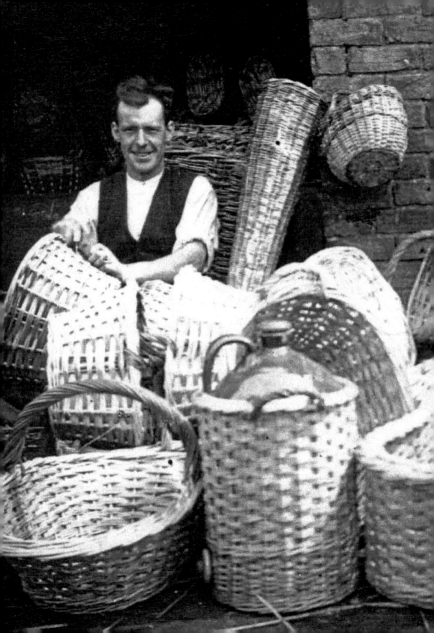

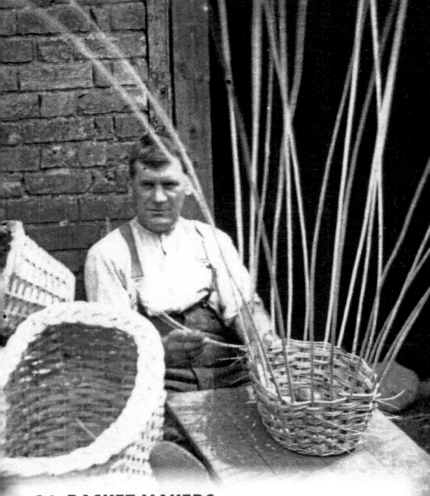

34. BASKET MAKERS

Ely had a thriving basketmaking industry near the river in the nineteenth and part of the twentieth century. Baskets, made from osiers grown nearby, were sold locally and at Bury St Edmunds market. Basketmaking in this area and also eel catching have now died out.

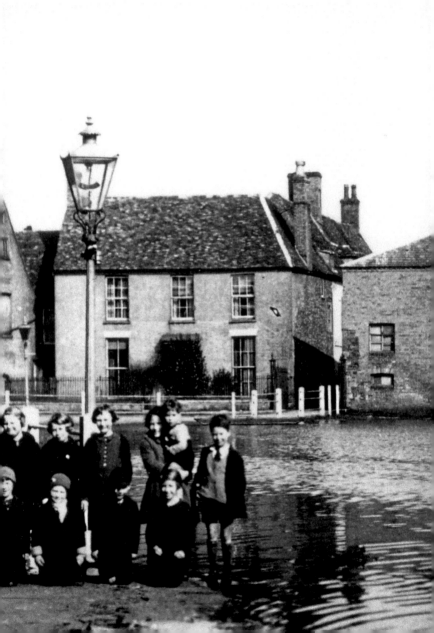

35. ANTIQUES CENTRE, HOUSE, BABYLON GALLERY AND FLOODS

Seen here on the extreme left is an antiques centre in an old granary, then an award-winning teashop in a former house. Close to the river is a former brewery, now the Babylon Gallery. Here too is a reminder that for many years there was flooding near the river and along the towpath. The Lincoln Bridge opened in 1966, until which time access to Babylon was by boat or ferry. This photo is typical of the many taken by Tom Bolton who meticulously recorded local events for around fifty years.

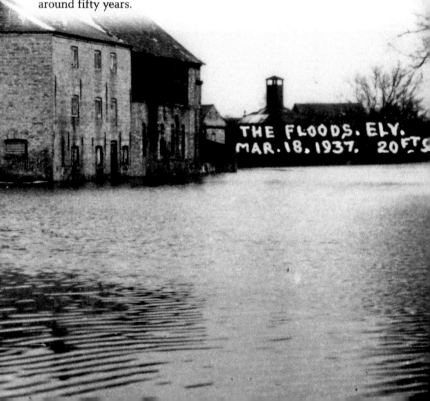

36. ROSWELL PITS

For a longer walk, continue by the river to the left to reach Roswell Pits. The 'Pits' were formed when, for over 300 years, Kimmeridge clay was dug out to build up the riverbanks so that, except in unusual circumstances, flooding of surrounding low-lying farmland was prevented. The Pits are also a refuge for a variety of wildlife including bitterns, which have been seen here recently. It was designated an area of Special Scientific Interest in 2009.

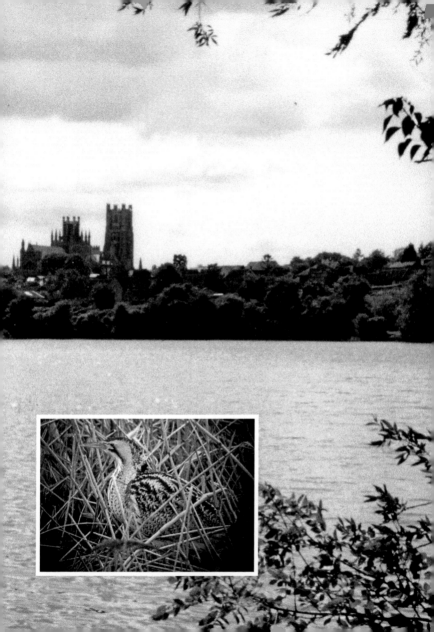

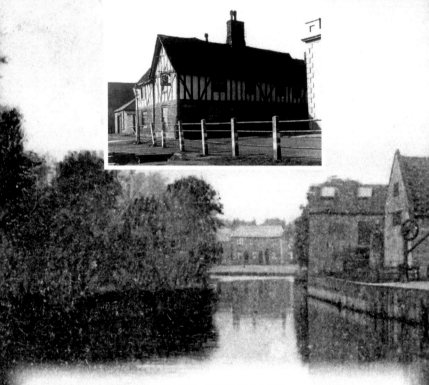

37. THE QUAY AND SHIP INN

At one time near here there were a number of hythes where goods of all sorts, including stone for the cathedral, were landed. The Ship Inn, the white building on the right, issued trade tokens during the seventeenth century to provide small change, not then minted. The inn had been open since 1661, closed in 1955 and was demolished by 1961. The inset shows the inn after the Second World War.

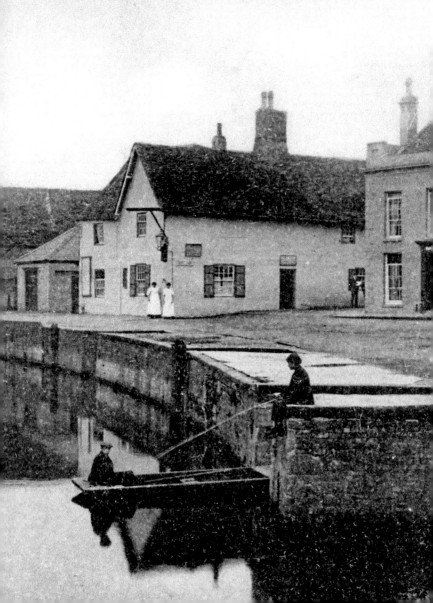

WATERSIDE, ELY.

38. CELEBRATIONS ON BABYLON, 1973

The monastery at Ely was founded in 673, by St Etheldreda. The thirteenth centenary was marked by a great many memorable events held throughout 1973. Look towards Babylon across the river where local families lived from at least the thirteenth century. It will never look the same again since today it is almost entirely occupied by a marina with moorings for over 250 boats.

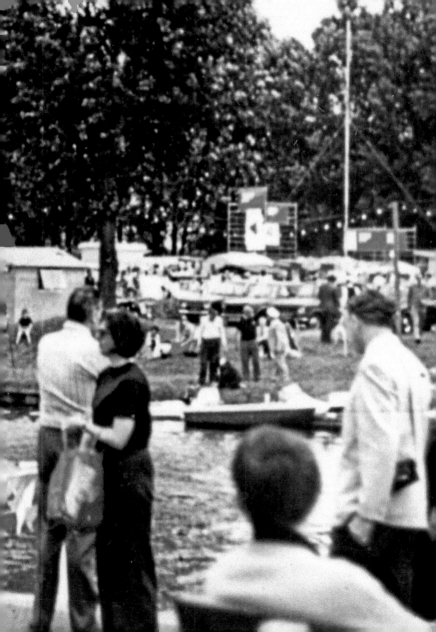

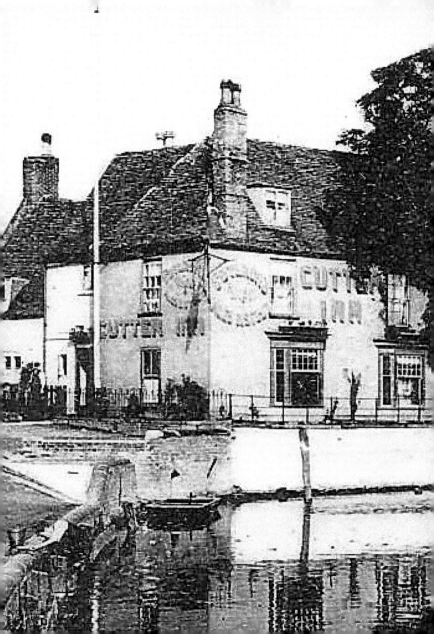

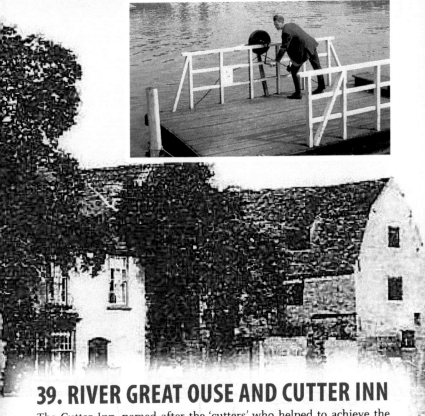

39. RIVER GREAT OUSE AND CUTTER INN

The Cutter Inn, named after the 'cutters' who helped to achieve the 'New Cut' that shortened the river route to Littleport, opened in 1830 and is now a popular venue for locals and visitors. The chain ferry that operated from here was the only access to Babylon until 1964. The Riverside Walk, officially opened in 1968, extends from beyond the quay to the Cutter and Ely High Bridge. Since 1977 Aquafest, a fun event, has been staged here annually by the Ely Rotary Club.

40. ELY HIGH BRIDGE, 1833

Around 400w metres along the footpath is the present bridge over the River Great Ouse, opened in 1982. This was built on the site of the 1833 iron bridge which followed a sucession of wooden bridges. A bridge here has long been an essential part of the route into Ely from the Newmarket direction. An intrepid traveller, Celia Fiennes, approached Ely on horseback along this causeway in 1698 and said 'El y looke finely through those trees (willows), and that stands very high'.

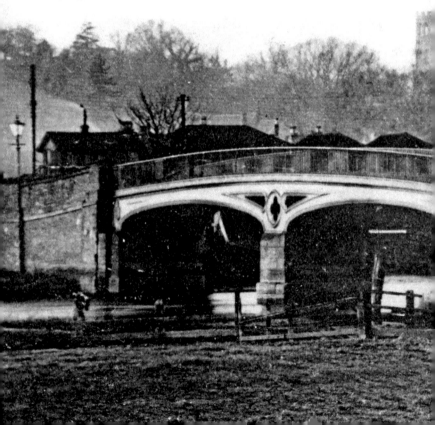

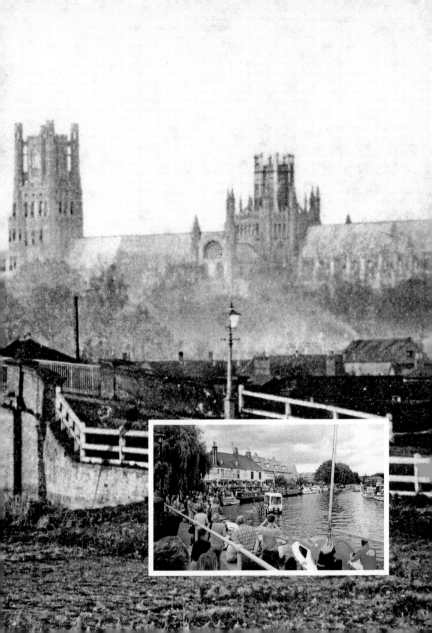

41. TIMBERED COTTAGES

These three cottages in Broad Street were demolished in the early 1930s to widen the entrance to a woodyard. In the 1990s the area became an archaeological site, where the foundations of medieval development were found. The City of Ely Council created the Jubilee Gardens, to link Broad Street and Cherry Hill Park with the river. Officially opened by the Duke of Edinburgh on 11 February 2002, the gardens still flourish and provide a venue for relaxation, concerts and other events.

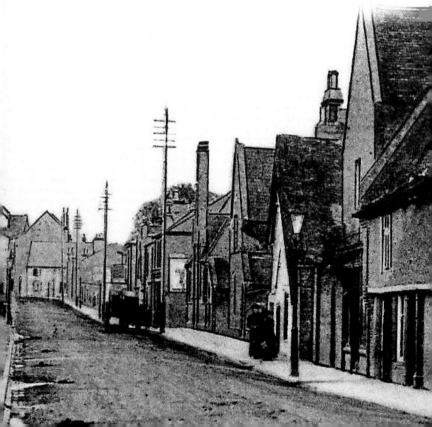

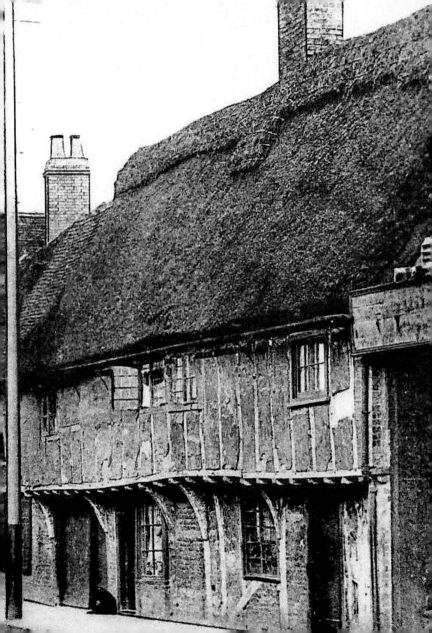

42. THREE BLACKBIRDS INN

This former merchant's house (later a public house) in Broad Street closed in 1932. Inside is a timber roof of 1250 and a series of stone hearths. It was partitioned to form separate dwellings until it became uninhabitable. Before Ely Preservation Trust purchased the property it had been reroofed. When research and restoration were completed in 1984, three housing units were offered for sale. Note too, the changed position of the road.

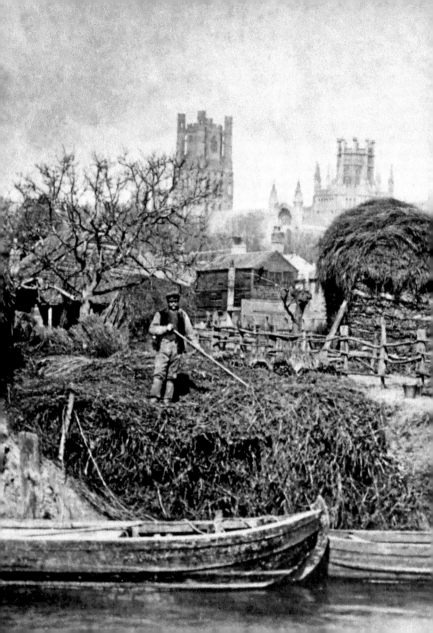

43. OSIERS

Near the river end of The Three Blackbirds site was Fear's rod yard where osiers, grown at nearby holts, were landed for making into a variety of baskets, chiefly for agricultural use. Rushes, grown near the river, were also landed here.

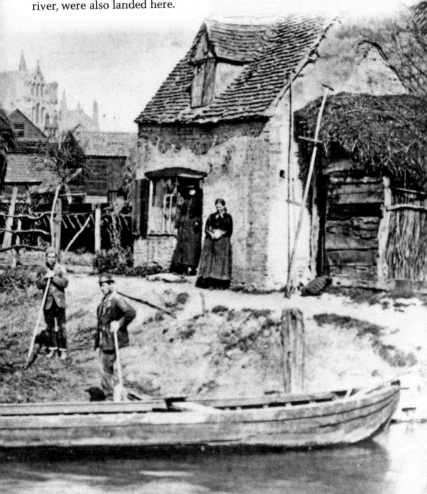

44. CHERRY HILL PARK

This area with Cherry Hill, a former castle motte, and the adjoining Dean's Meadow are owned by the Dean and Chapter of Ely Cathedral. The Park, now often called Cherry Hill Park, was at first leased by Ely Urban District Council in 1964.The lease is now held by East Cambridgeshire District Council. It provides an open space for public use and links the Jubilee Gardens to the Porta and the precincts.

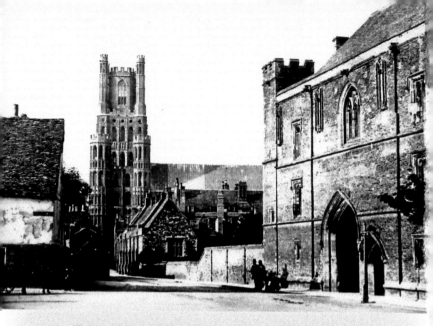

45. FORMER GREEN MAN, CATHEDRAL AND THE PORTA

The Green Man on the left was where Canon Hitch lived at the time when Oliver Cromwell, in January 1644, ordered him to 'leave off your fooling and come down' from the cathedral altar. Continue along the gallery and soon the cathedral west door will be reached, inviting visitors to end their tour by entering the cathedral and seeing in front the whole length of this amazing building.